PIGEONS

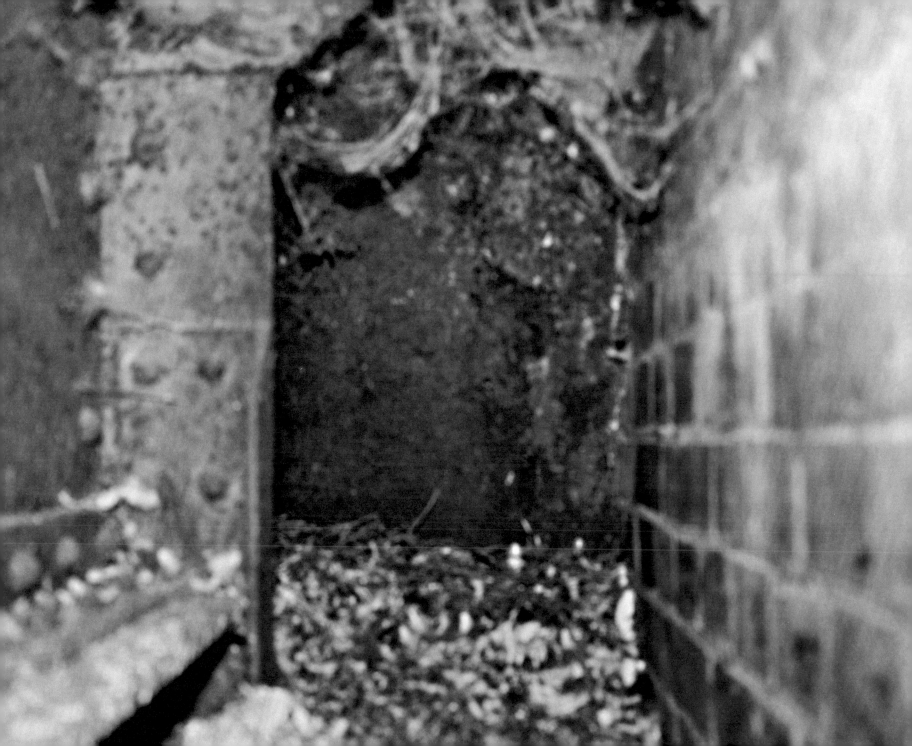

PIGEONS
STEPHEN GILL

Words by Will Self

ARCHIVE OF MODERN CONFLICT

NOBODY

Perhaps the most tired trope concerning the urban pigeon is that you never see their young – there are no fluffy little pigeon chicks or hatchlings to arouse our sentimental feelings, instead, day in day out, we are confronted by fully formed flying rats. Their wings are tattered and filthy, their breasts are mangy, their beaks and heads are deformed by excrescences that bear an uncanny resemblance to their own hardened faeces. They hop on deformed legs, or else vainly strut about among the rest of the detritus the city ceaselessly evacuates – posturing by a Styrofoam beaker, or striking an attitude under the halo of plastic bag. They are with us far more than the poor ever are – unless, that is, you happen to be poor – and it may be for that very reason that we feel so entitled to our willed ignorance of them. They have no children, the pigeons, because if they were to we might have to pay some attention to them; we might open out free newspaper on the tube and see an advertisement for Pigeon Aid, featuring a colour photography of a benighted infant pigeon, shivering in a gutter, underneath him or her the slogan: JUST 15P COULD GIVE THIS PIGEON A HOME, FRESH WATER AND FOOD FOR A WEEK. Instead we have only adult pigeons, and since they are without family or visible means of support – apart from the stuff they scrounge from us – we're secure in our assumption that they're they occupy the same ecological niche as the 'undeserving poor' of our own species.

Sometimes in my local park I see people feeding the pigeons. They've come with a bag full of breadcrumbs and they scatter it across the path then stand back and watch as the pigeons come in to wheel about their heads and then settle down to feed: a mutteration of little self-important bipeds, wandering back and forth and round and around, seemingly reducing the business of survival to the status of a Mediterranean passageo. When I see this I usually have to restrain myself from going up to the feeder and remonstrating with them along these lines: Don't you realise these creatures are riddled with dirt and disease, the last thing you want to be doing is encouraging them –really the best thing we can hope for is that they go quietly extinct, after all they fulfil no discernible function. That I don't do this is a

function of many countervailing thoughts: the pigeon feeders are often elderly, or they come from minority groups – in both cases I patronise them with my pitying eyes. Ah, I think, you poor soul, you come from a time – or a place – when there was a more intimate connection with nature than we have here, in the relentlessly anthropic city; when the pigeons come wheeling in around you, the pearly-grey vortex becomes a wormhole through which you can escape your own benighted existence – who am I to deny you this crumb of pantheistic comfort? Or else I think: Poor soul, perhaps you have no family of your own, and so the strange and exciting fractals that the pigeons' wings beat into being appear to you as a downy blanket, laid down by love on your careworn and lonely body?

It's always a mistake to allow these countervailing thoughts to gain any purchase – to perch, brooding on the upper storeys of my psyche – for, no sooner are they given house room than they proliferate: Is not the reason why I find myself so readily empathising with the pigeon-feeders that I identify with them? Are we not all exiled from an edenic realm where humans and animals lived together – if not in harmony, than at least with the full acknowledgement that we all had a right to exist? And am I not also an exile from the past? True, I'm not old enough – nor am I from the right social class – to remember a time when many households had members who were happy to be called 'pigeon fanciers', but nonetheless, I grew up in a London where pigeon racing was part of the general sporting culture, and prodigious acts of homing – such an evocative word! – had as much currency as goal-scoring or marathon-running. And I also grew up in a London where, when you walked through Trafalgar Square, and many of the city's other open spaces, you'd see men and women transformed into astonishing human flutterings, as they willingly surrendered themselves to the flock. As much as red phone booths and post-boxes, hunchbacked black cabs and the bold roundels of London Transport, the pigeon was a valorised icon of the metropolis – tourists would pose for their photos with them, and so would locals.

The London of my childhood featured great grey-beige

and brown-black cliffs of masonry streaked with guano; in the mainline rail terminuses pigeons flapped about the dirty volumes of the glass roofs, and no one seemed to register their presence any more than they did that of their fellow passengers, and the confusion of internal and the external acted in the birds' favour, normalising them. Alfred Hitchcock, Modernist architecture, and Health & Safety put paid to that. I well remember the impact that Hitchcock's The Birds had on the collective psyche – my school friends couldn't stop twittering about it; and it was only the vanguard of a whole formation of eco-paranoid cultural products that, in the 1960s and 70s, came home to roost on a society that, while professing a great love of nature, has nonetheless ensured that in our right, tight little island it is trammelled, clipped and shaped into a moribund topiary. Oliver Rackham, the great historian of the English countryside, has written that there were two great periods of transformation wrought on our environment: the first came in the Iron Age, when improved felling technologies led very quickly to the clearance of the primordial woodland; and the second came in the latter half of the 19th century, when the obsession with shooting resulted in the coverts we find today: brooding islets of the anti-natural, surrounded by seas of monoculture, in which pheasants wait out their days, eating from bins, until the time comes for them to be shot.

In the cities the coverts are of concrete and plate glass – there's no sport shooting, but instead we have the serious business of keeping the vermin at bay. We are all psychic gamekeepers now: implanting nylon barbs on ledges and sills, lest the birds gain the upper hand; the old association between sulphurous coal smoke and sooty wings has gone – the bathetic recapitulations of postmodernism don't allow for guano detailing; and our acute fear of mass infection has led each and every one of us to establish a personal cordon sanitaire; now, the only place we want to see 'pigeon breast' is on the menu of a gastropub. I grew up in the London 'burbs, and they were leafy enough. At the crepuscular beginning and ends of the days, the first and the last things I would hear would be the distinctive bronchitic coo-burbling of the pigeons, a sound at once prosaic – reminiscent of an old-fashion telephone bell, but in a much lower register: Brrrr-brrr, brrr-brrr – and thrillingly creepy. If there's one sound that encapsulates the Freudian conception of the uncanny, as being that thing that is at once redolent of home, and yet not quite right then it must be the massed susurrus of the birds.

Stephen Gill's photographs are devoid of sentiment or affectation – rather than showing the pigeon in our world, they take us into theirs. The lens noses in under bridges, squeezes through cracks and scopes out crannies. These are images that bestow on the despised flying rats that oft-trumpeted – but seldom realised – attribution: their dignity: here are pigeons making their lives in a natural landscape, for, whatever else humans may be, we are animals too, and as such our buildings are analogous to the earthworks of termites, and our bridges to the dams of beavers. It's this inversion of the anthropocentric view that makes Gill's images so compelling – that, and another revelation; for, fluffed-up and blinking, in the dust and the grime and the rust and rime, we see those mythical beings: the young pigeons. I suspect it's because we've entered this otherworldly realm that we find these juveniles to be arousing not of pity, but a grudging respect – far from being scroungers, or undeserving poor, these doughty birds survive and even thrive, despite barbs and more barbs of outrageous human fortune. They are, like the urban foxes, the economic migrants of the animal world: forced into the cities to scratch a living as best they may, and before we condemn them we would do well to ask ourselves this question: would we do as well were the tables to be turned?

Will Self

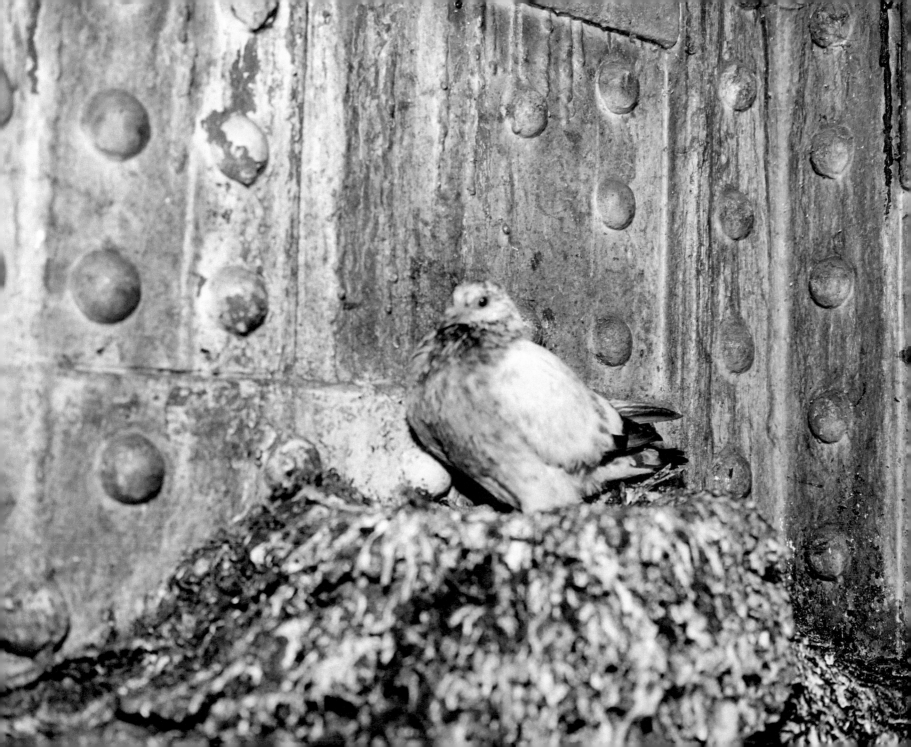

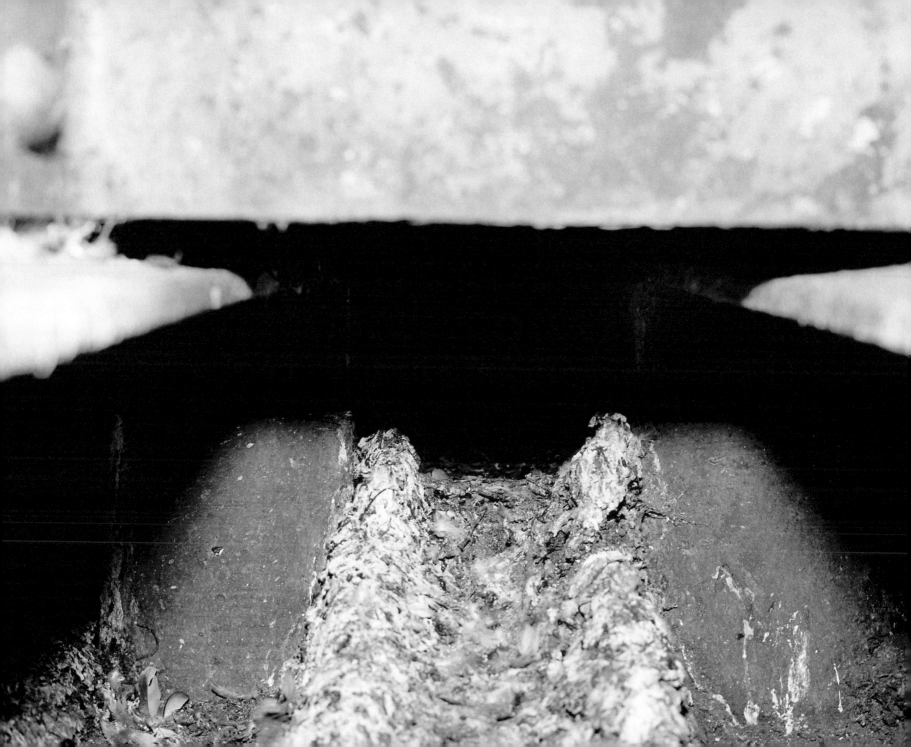

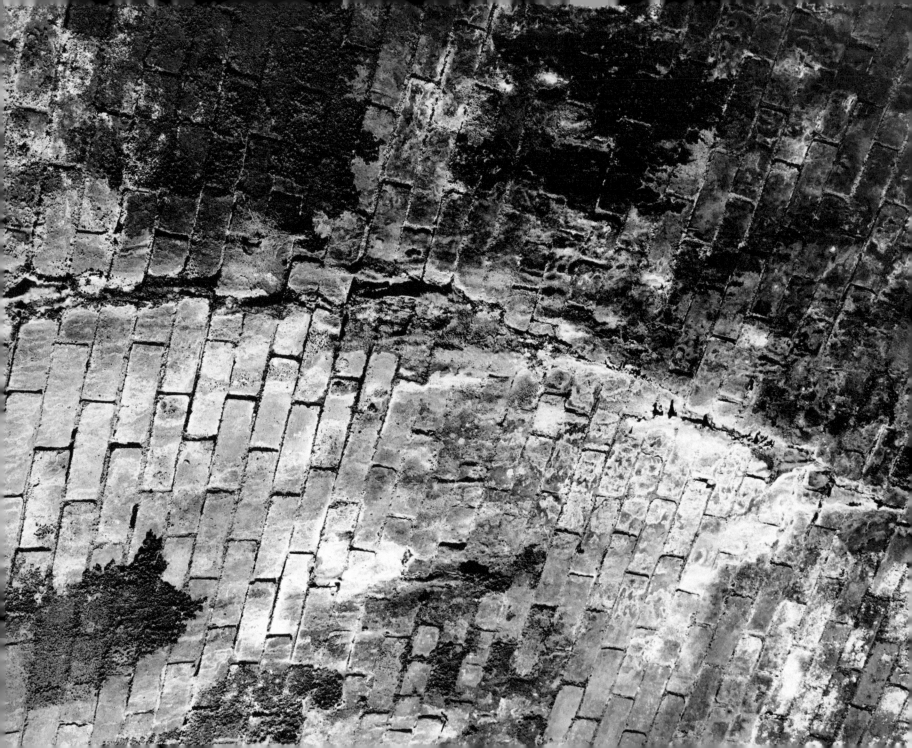

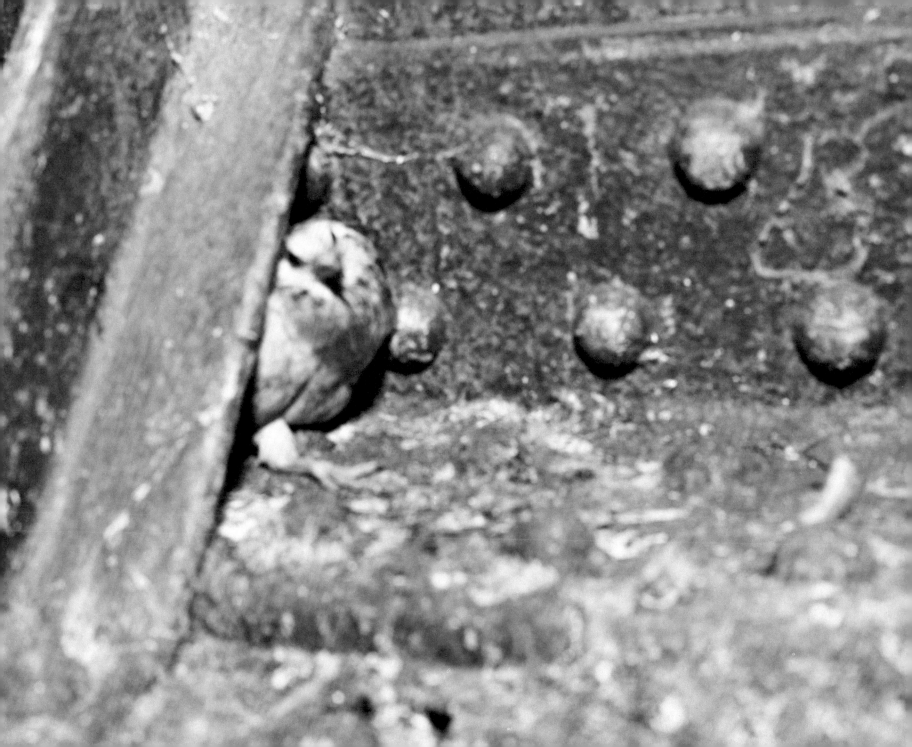

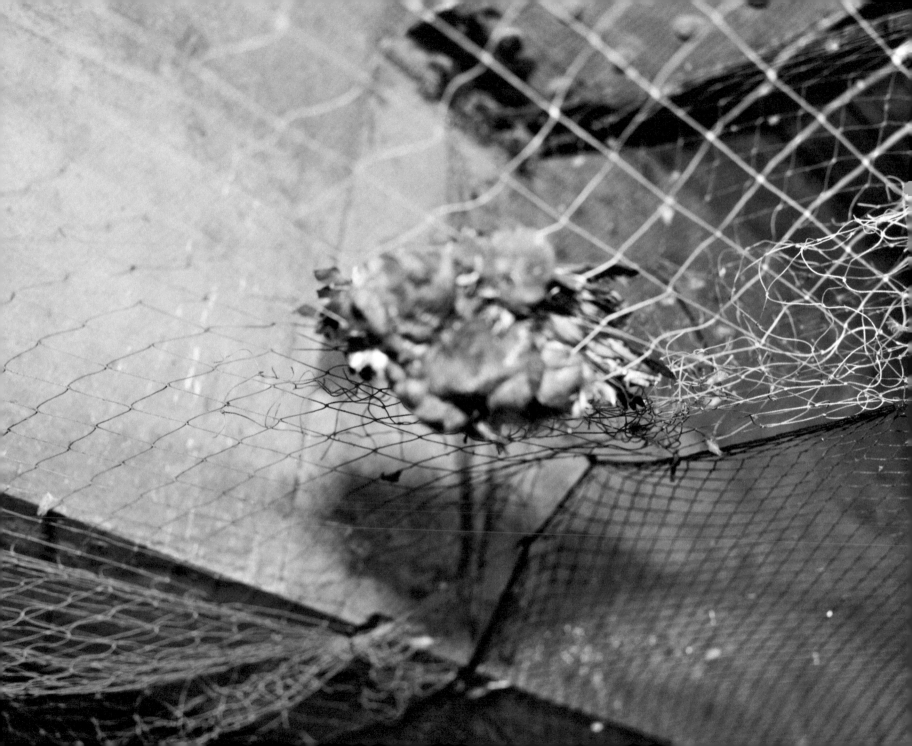

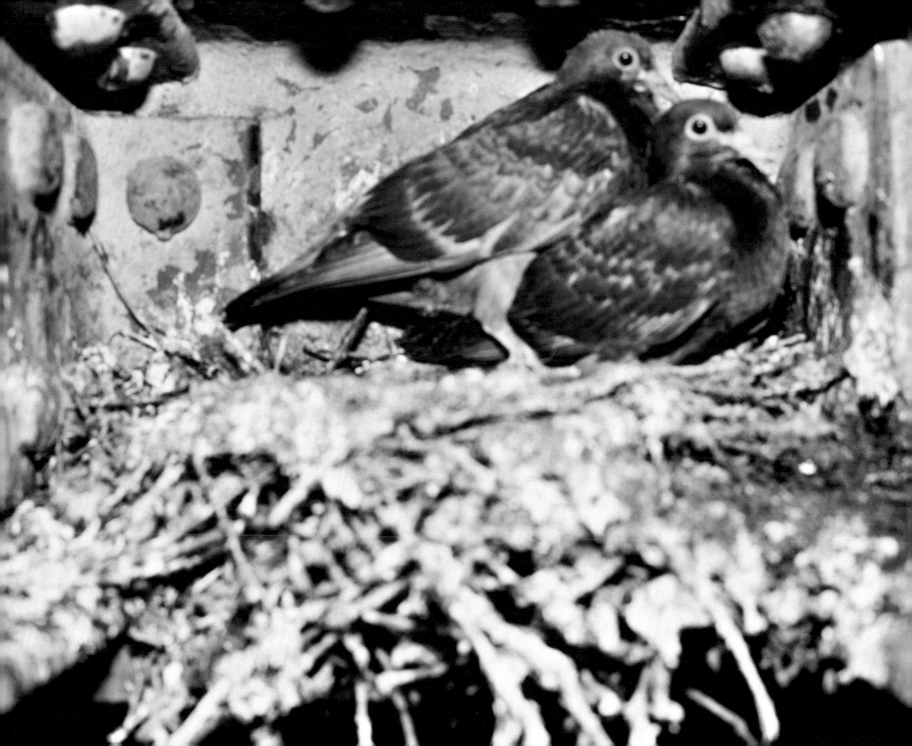

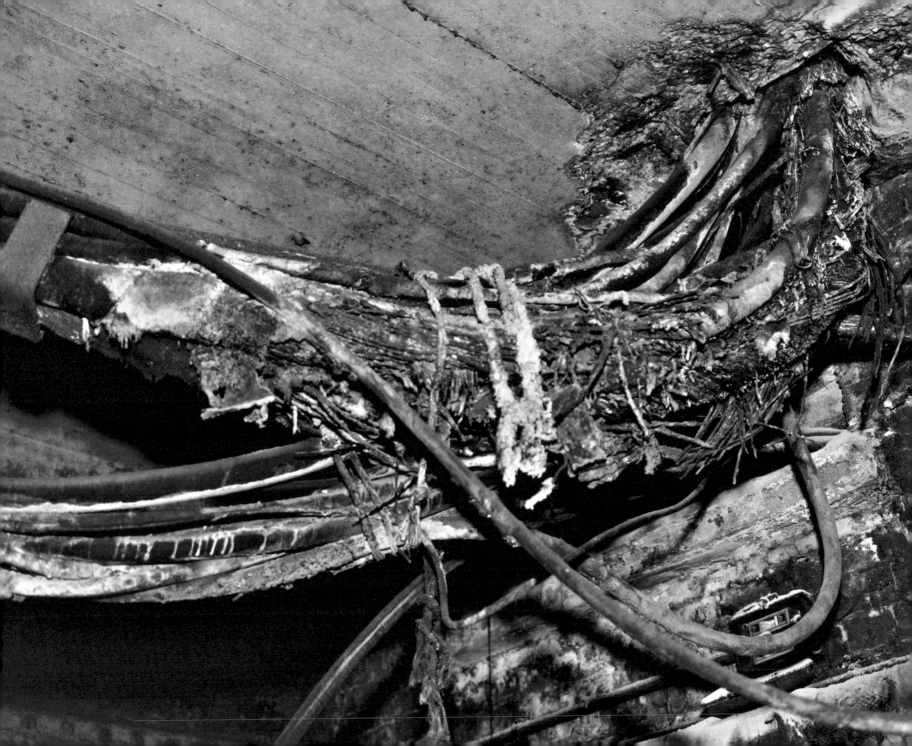

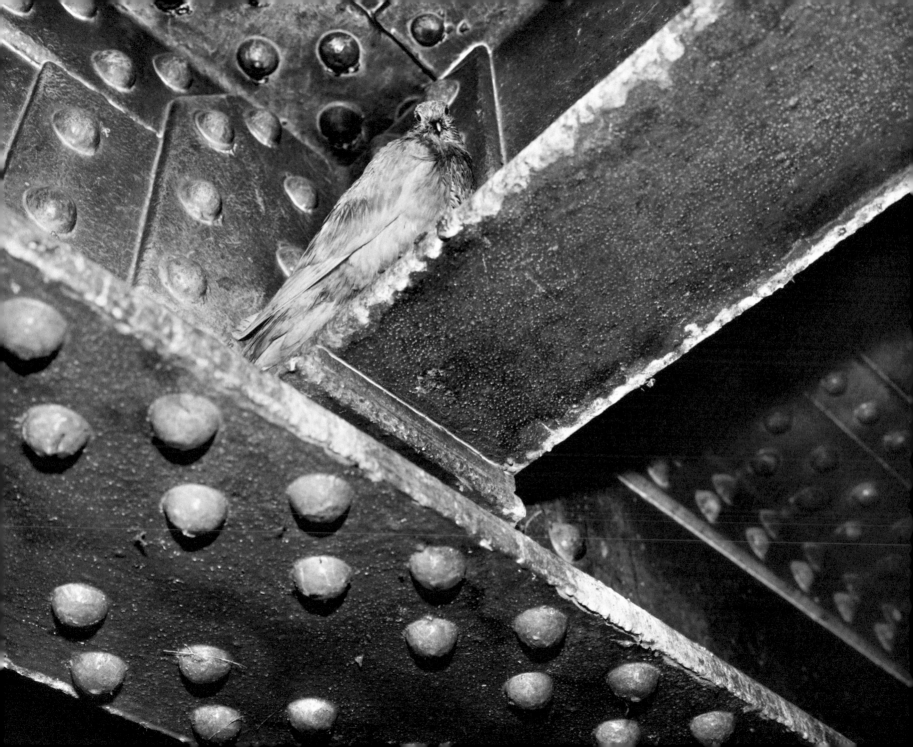

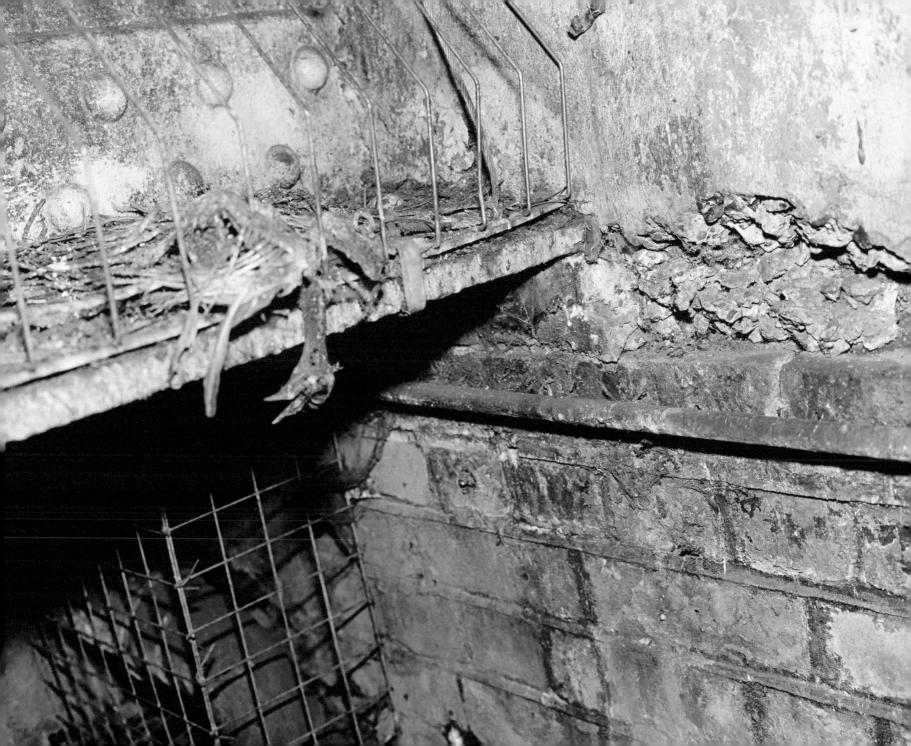

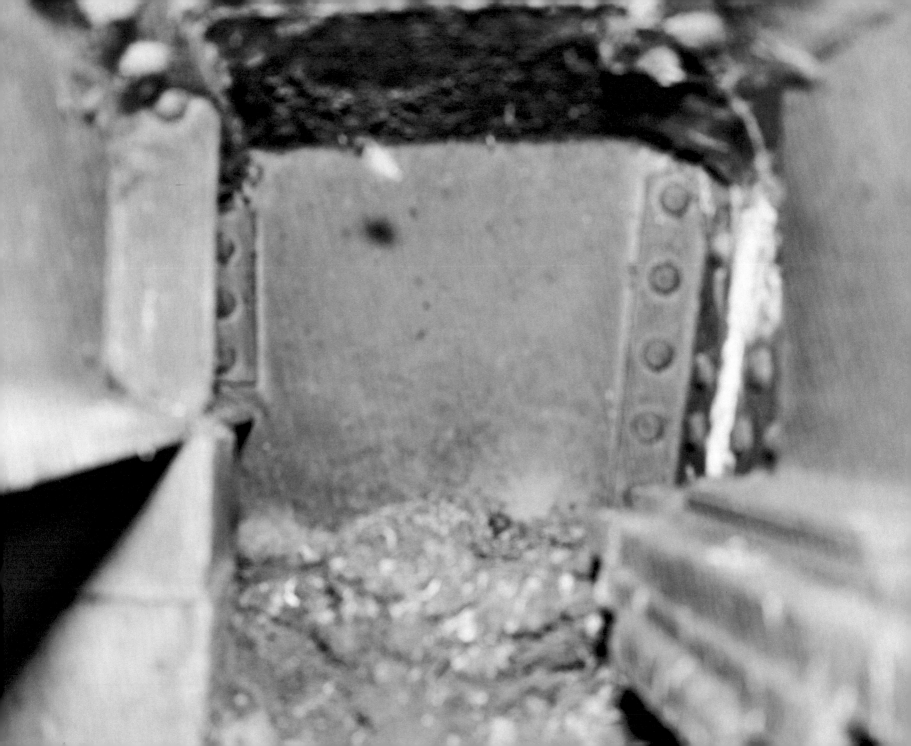

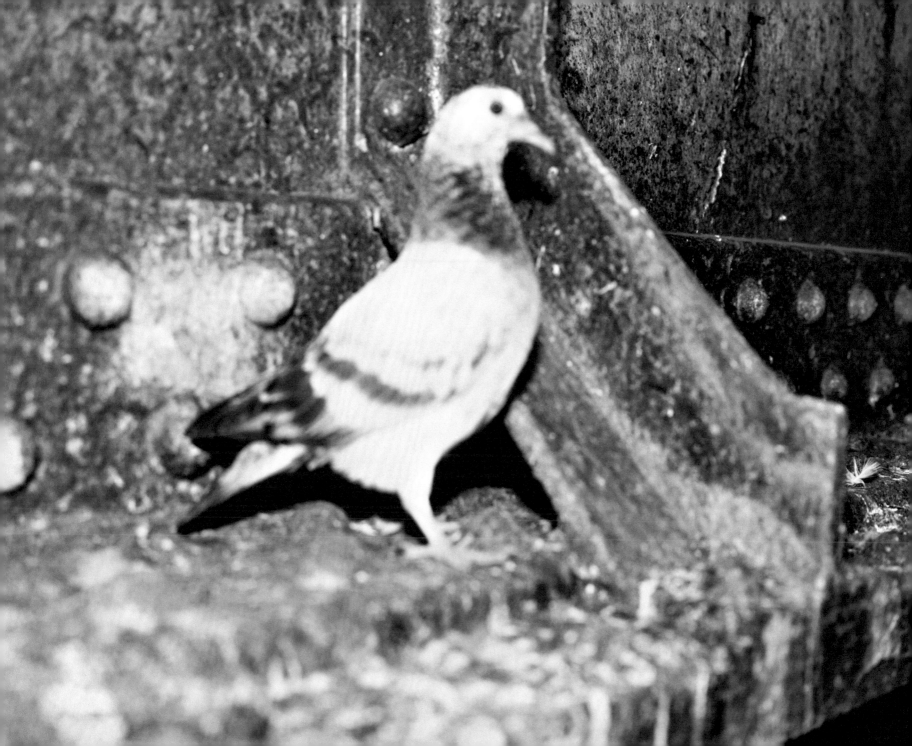

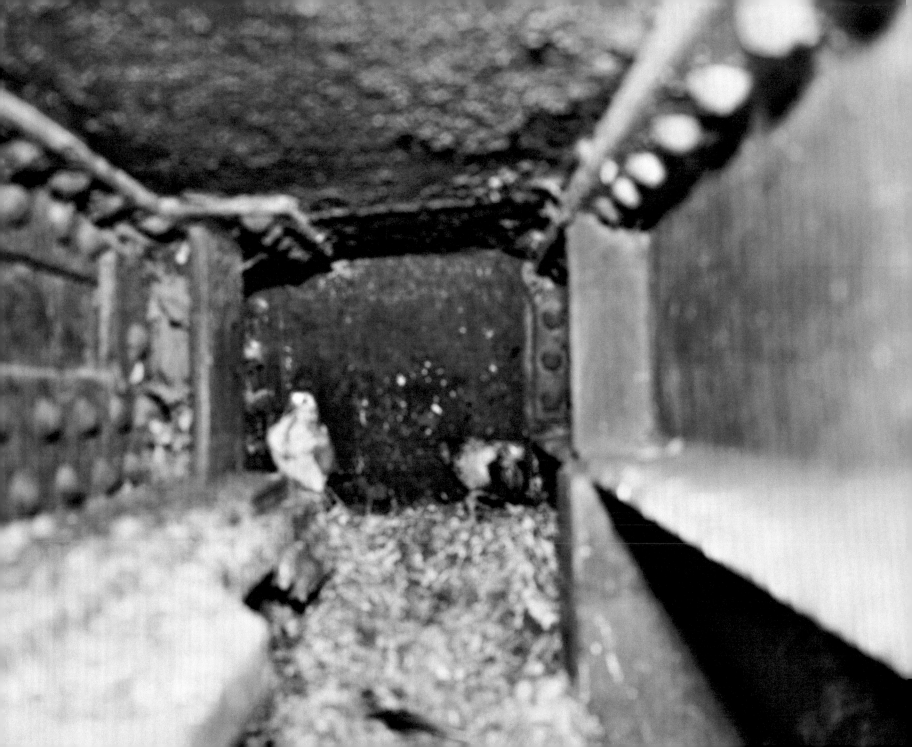

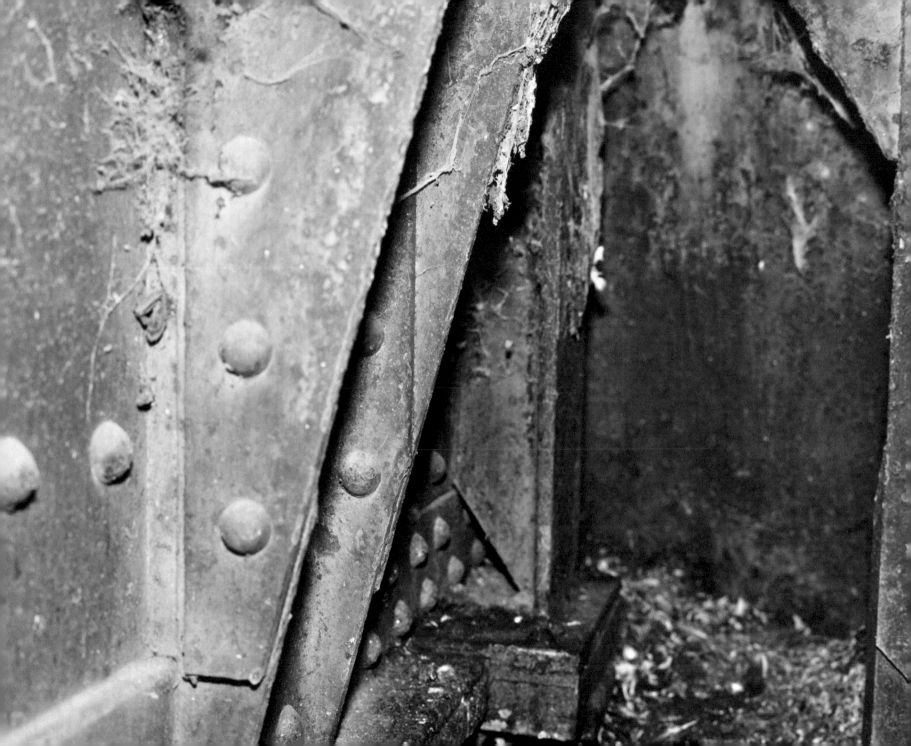

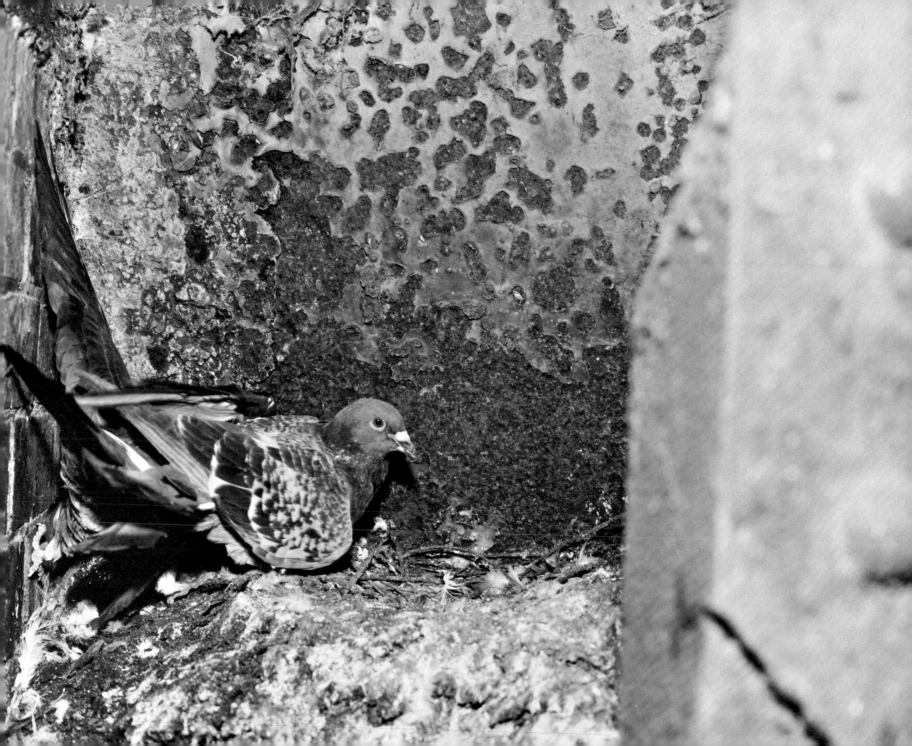

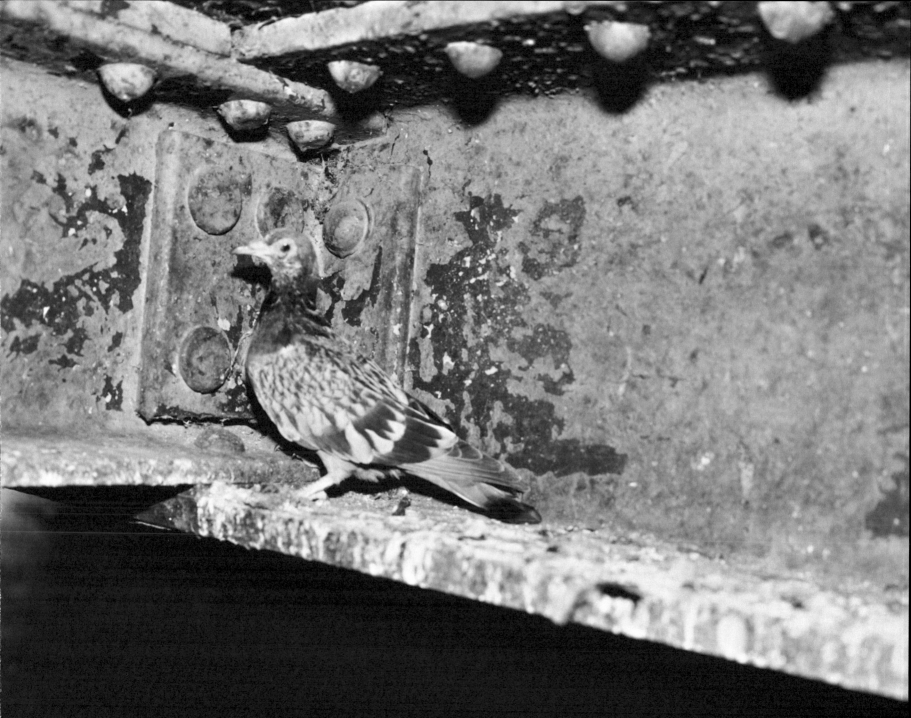

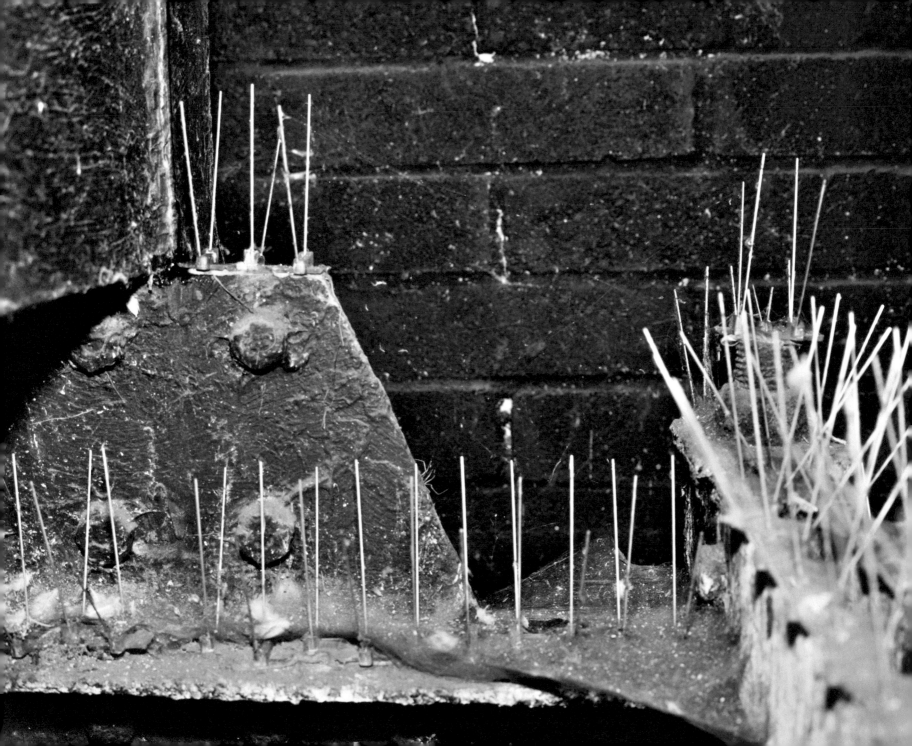

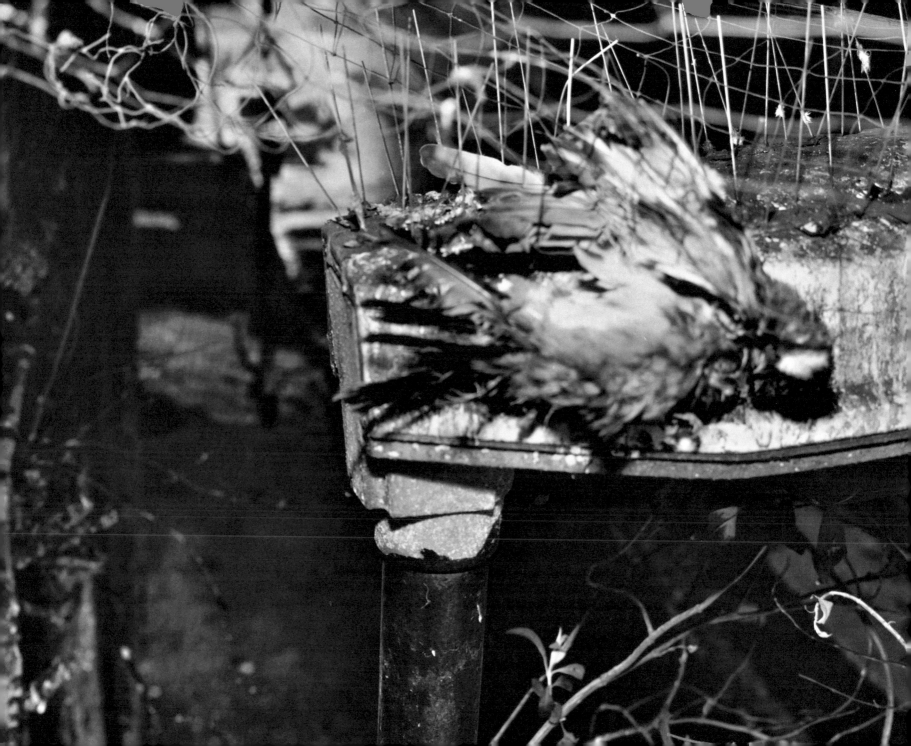

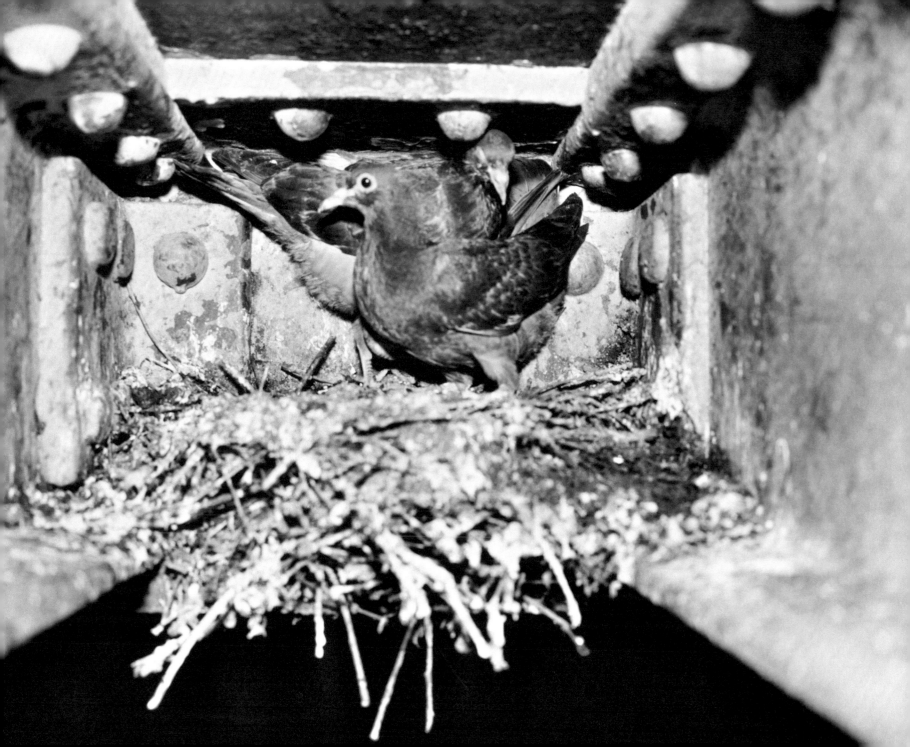

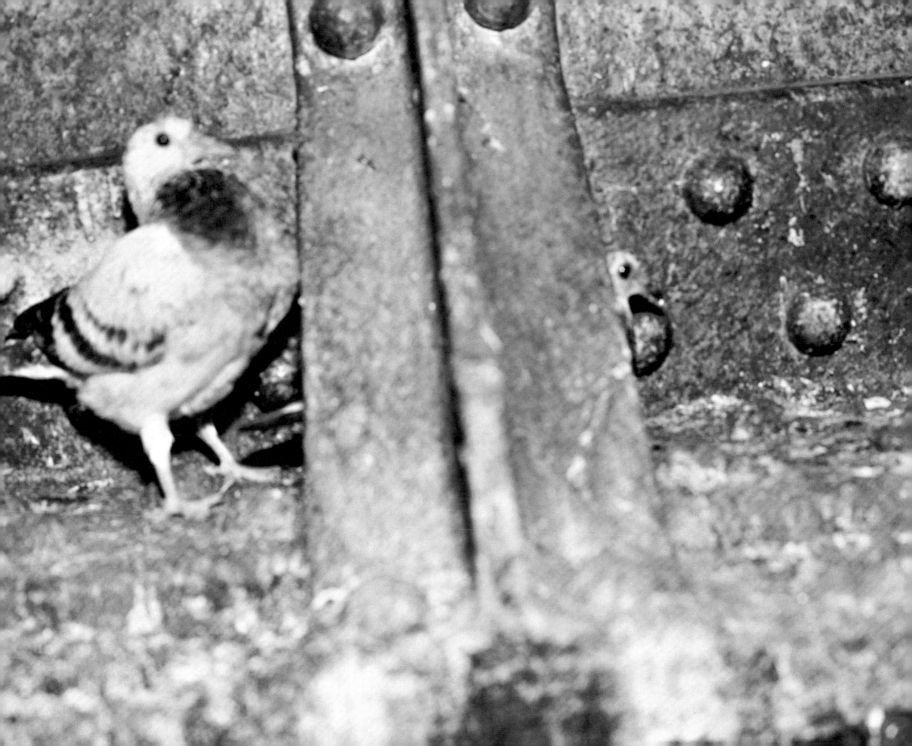

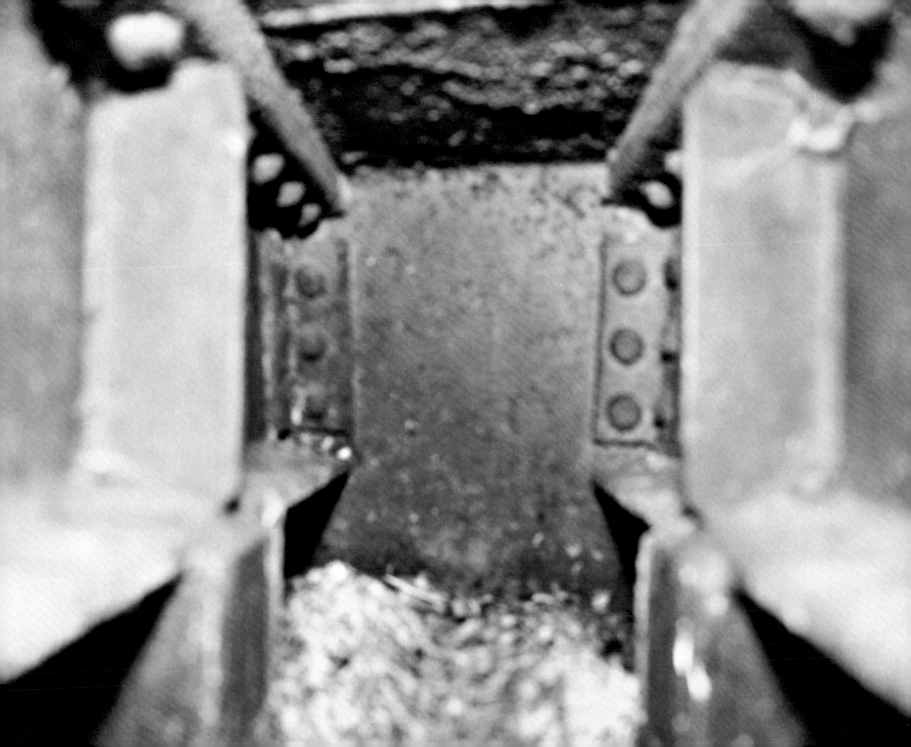

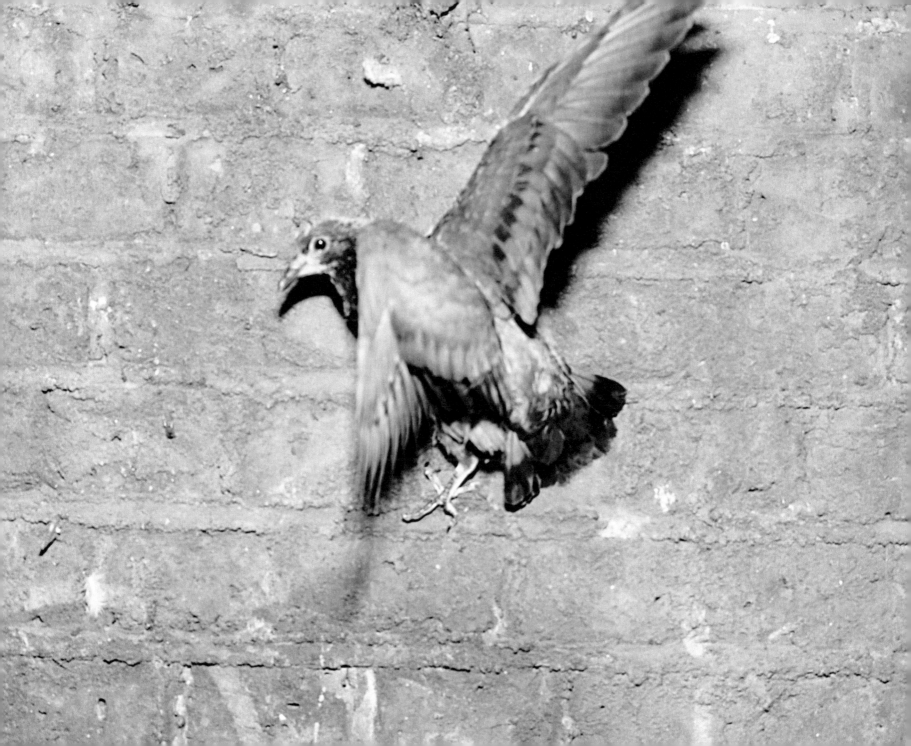

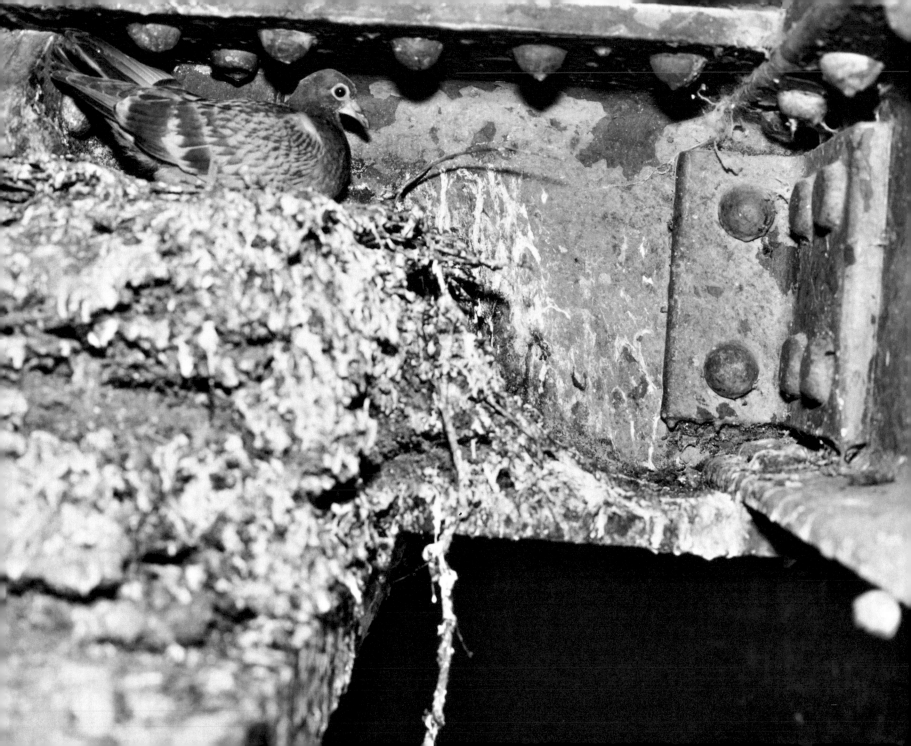

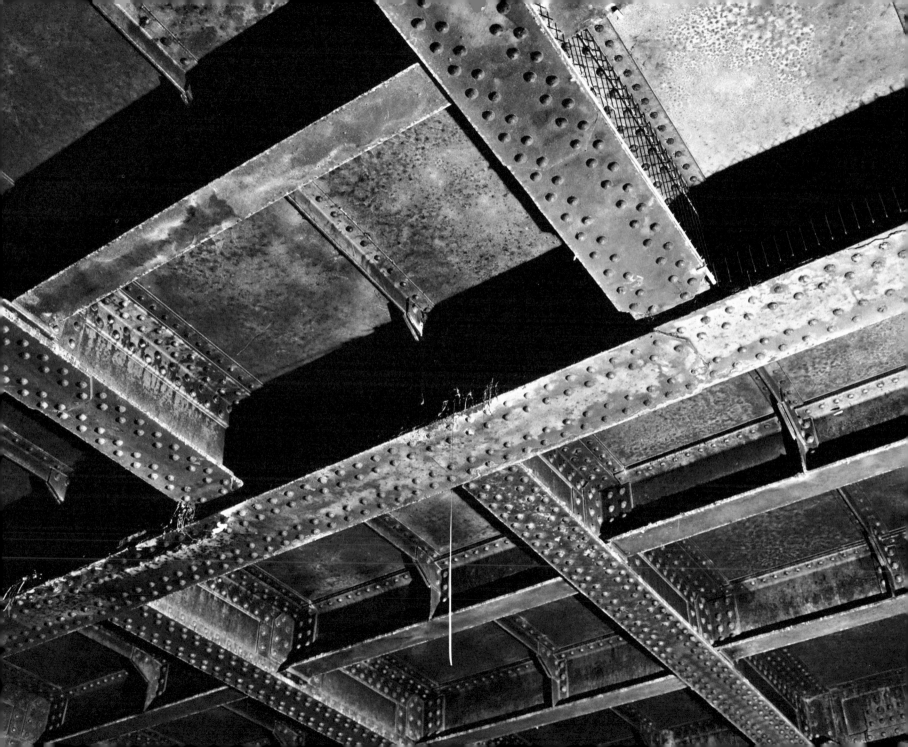

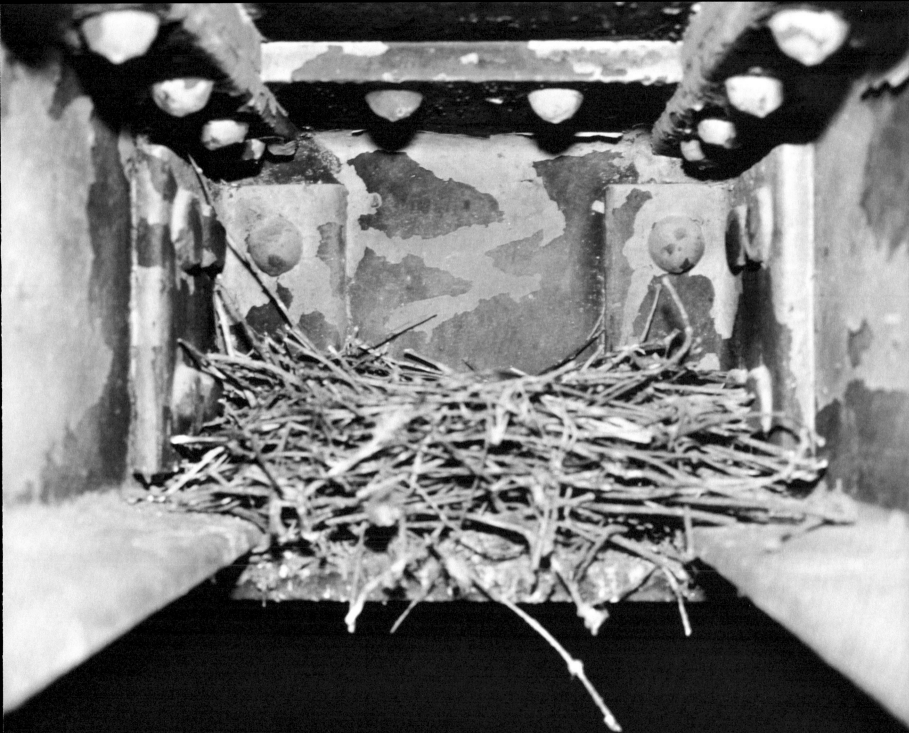

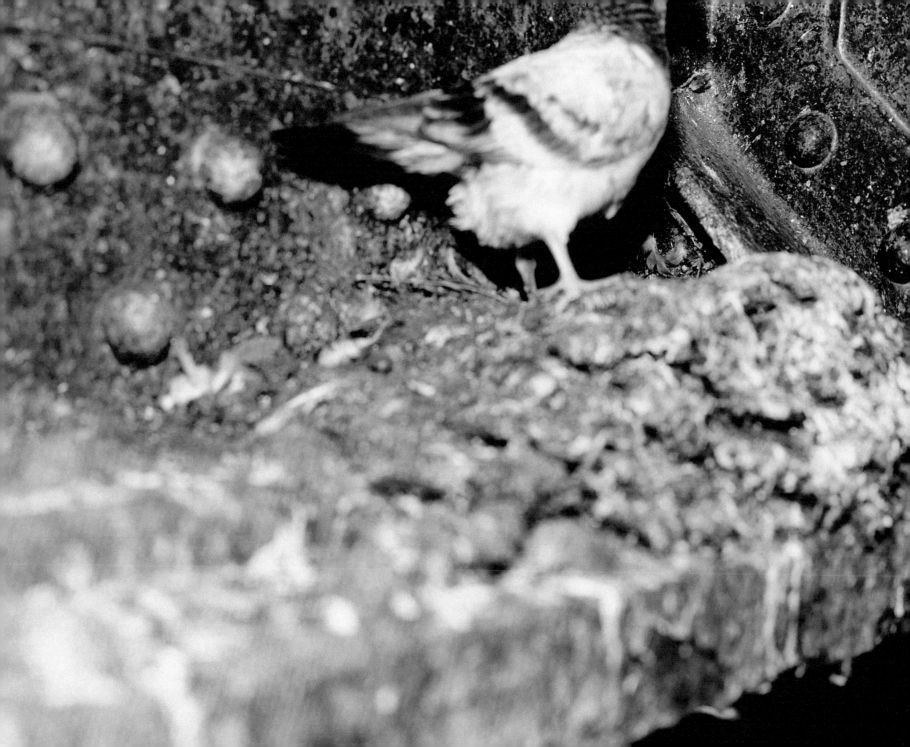

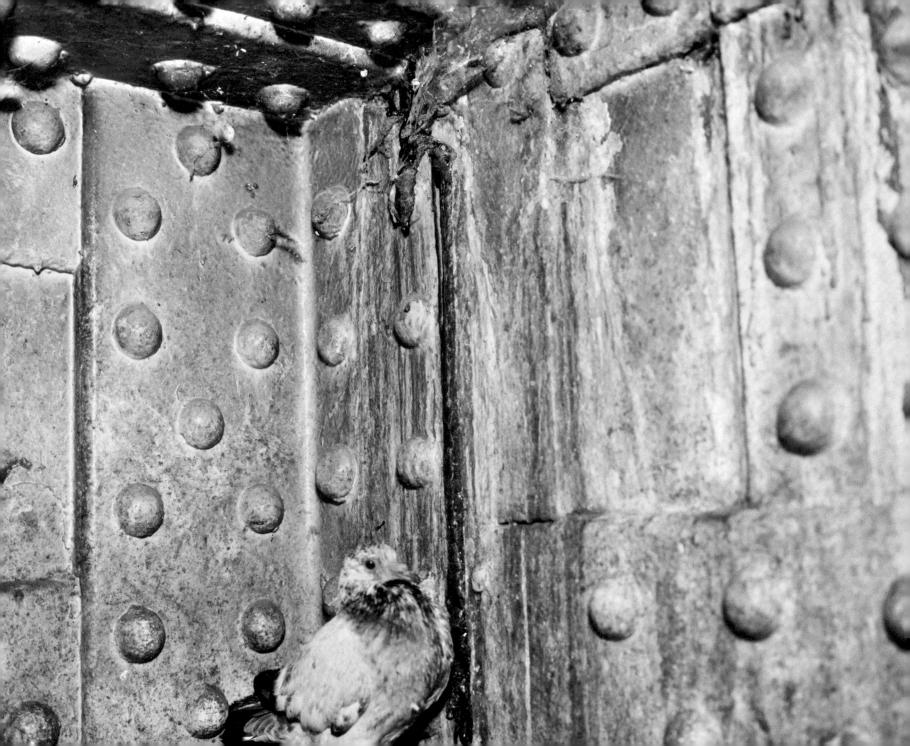

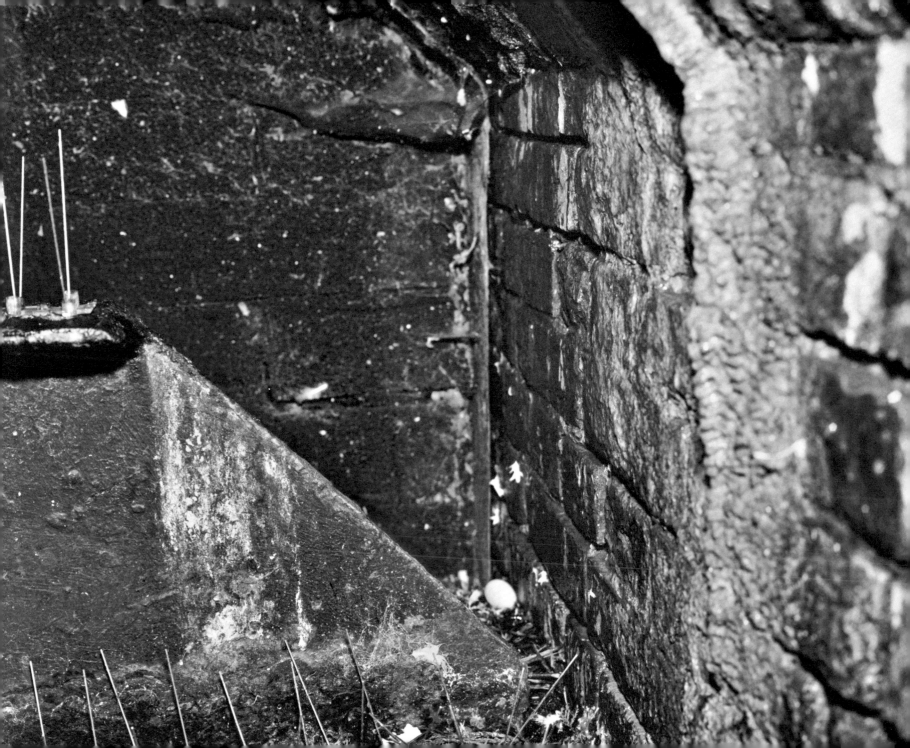

PIGEONS
Photographs by Stephen Gill
Introduction by Will Self

978-0-9575369-7-5 Pigeons
978-0-9575369-8-2 Pigeons Special Edition

Published 2014 by Nobody in association
with the Archive of Modern Conflict

Edited, sequenced and produced
by Stephen Gill

Book design Melanie Mues

Book printed in Italy

Thank you to – My family Lena, Ada and Ylva
also to Mengxi Zhang, David C West, Rob
Sara, Mikiko Kikuta, Richard Green, Will Self,
Four Corners, Timothy Prus and the staff at
the Archive of Modern Conflict

A CIP catalogue record for this book is
available from the British Library

Other books by Stephen Gill include
Invisible, Hackney Wick, Buried,
Archaeology in Reverse, Hackney Flowers,
Anonymous Origami, A Series of
Disappointments, Coming up for Air,
B Sides, Coexistence, Talking to Ants,
Hackney Kisses and Best Before End.

www.stephengill.co.uk
www.nobodybooks.com